3 0 DEC 1993

- 4 MAR 1994

22 AUG 1996

- 7 NOV 1994

27 FEB 1995

24 JUL 1997

1 5 DEC 1997

27 FEB 2001

23 MAR 1995

26 MAY 1995

- 6 APR 2001

1 8 MAY 2001

27 JUN 1995

1 3 MAY 2002

1 3 JAN 2003

1 2 OCT 1995

02 FEB 2009

27 NOV 1995

26 OCT 2013

MIDLOTHIAN COUNCIL LIBRARY

1 8 APR 19

WITHDRAWN

Phaidon Press Limited
140 Kensington Church Street
London W8 4BN

First published in Great Britain 1992

© Parramón Ediciones, S.A. 1991

ISBN 0 7148 2814 9

A CIP catalogue record for this book is
available from the British Library

Printed in Spain

Learn to paint with

Water Colour

256883 J 751

Materials, skills and
step-by-step projects

Watercolours

Learning to use watercolours

This book has been designed to help you learn how to draw and paint. It tells you about the materials you need and explains the various skills used to create different effects with watercolour paints. Start by reading about the basic skills, then follow the step-by-step projects later in the book to practise and gradually improve what you've learned. Any terms you're not sure of are explained in the Glossary at the back.

This book is divided into three parts: the first part tells you about the materials you need; the second part explains the skills of watercolour painting; the third part contains step-by-step projects to follow.

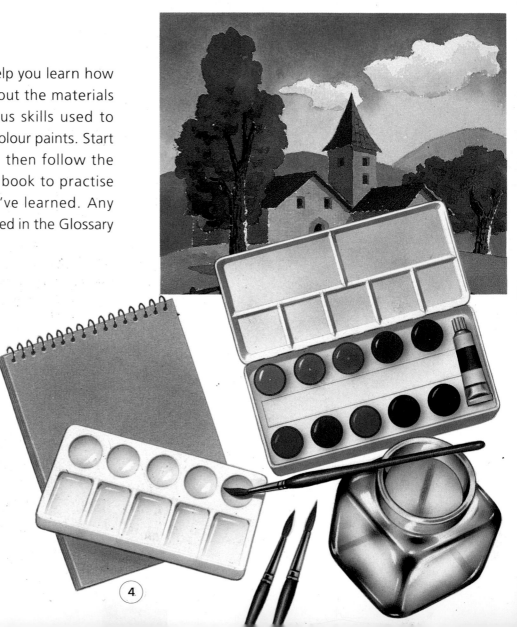

What is watercolour?

Watercolour is a painting method in which colours are diluted with water. Wet the colour with a damp brush. The colour will be lighter or darker depending on the amount of water you apply with the brush.

The most special quality of watercolour painting is its transparency. When the colours are diluted with water, the white of the paper below can be seen.

When you paint with watercolours, you need to remember two things:

○ paint light colours first and then darker colours;

○ use the colour of the paper to provide the white. (White paint is available, but it is used only in special cases.)

To see how watercolour paints work try painting a yellow strip, and when it is dry, covering it with a blue strip. The two colours blend and produce green.

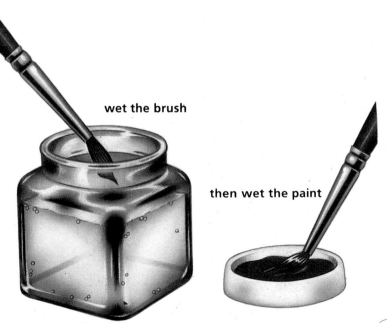

wet the brush

then wet the paint

paint light colours first

and then the darker ones

How to choose them

Types of watercolour paints

There are two types of watercolours: cakes of dry watercolours and tubes of thick, moist watercolours.

To pick up colour from a dry watercolour cake, you need to rub it often with a wet brush. Dry watercolours are best for beginners.

Watercolour tubes are suitable for painters with some experience.

You can start watercolour painting using a paintbox of dry watercolours.

Use the box lid as a palette to blend your colours.

The colours you need:

1 Light yellow
2 Dark yellow
3 Yellow ochre
4 Orange
5 Red
6 Light green
7 Dark green
8 Light blue
9 Dark blue
10 Black
11 Tube of opaque white

The colours in your paintbox are easy to change or replace.

round cakes of dry watercolours

square cakes of dry watercolours

tubes of thick, moist watercolours

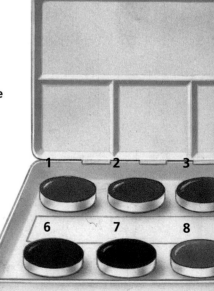

watercolour box

Paint brushes

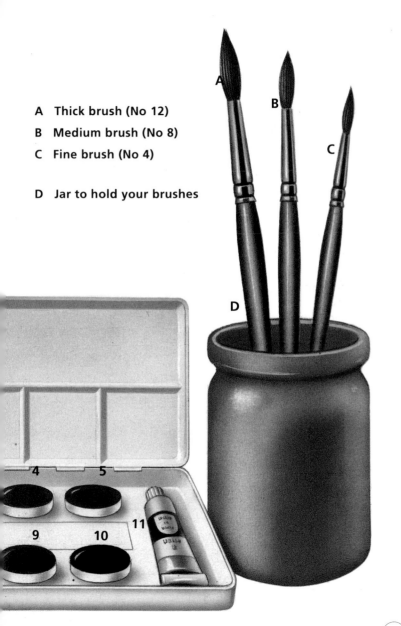

A Thick brush (No 12)

B Medium brush (No 8)

C Fine brush (No 4)

D Jar to hold your brushes

Choosing the right brushes

If you have never painted before, the brushes may seem a bit difficult to hold. They soon become easier to manage with practice.

There are several sizes of brushes, which are numbered according to the amount of hair they contain.

Sizes are identified by a number on the handle, from 00 - the finest brush, to 14 - the thickest one.

When you start to paint with watercolours you will just need two or three round brushes - numbers 4 8 and 12.

Looking after your brushes

○ Avoid letting paint dry on the brushes

○ After painting, wash and dry the brushes, smooth them out to their original shapes, and store them with the hair pointing up

What to paint on

Choosing the right paper

For watercolour painting you need special water-colour paper. You can find smooth (hot-press), medium (cold-press) and rough paper. Smooth paper is for detailed work. Rough paper is for freer painting but is difficult to use. Medium paper is the best for beginners.

1 **Rough paper**
2 **Medium (cold-press) paper**
3 **Smooth (hot-press) paper**

Paper pad

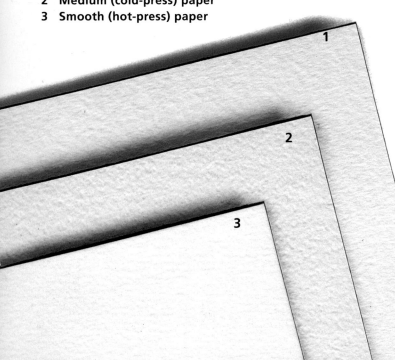

Watercolour pads

Watercolour paper comes in loose sheets as well as in pads mounted on cardboard.

For your first watercolour paintings, the best thing to use is a watercolour pad.

Stretching watercolour paper

Many experienced painters use sheets of watercolour paper that they stretch themselves.

Stretching paper prevents it from warping and forming pockets when the paint dries. Moisten the sheet of paper under a tap or with a sponge. Place the wet paper on a wooden board and smooth it out with your hands.

Working quickly, fasten the paper to the board with a strip of sticky tape along one edge. While still smoothing it, tape the other edges in position.

After drying in a horizontal position for three or four hours, the paper will be ready for watercolour painting.

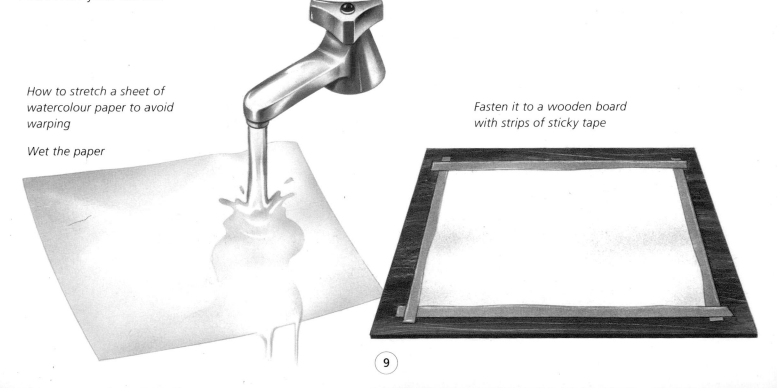

How to stretch a sheet of watercolour paper to avoid warping

Wet the paper

Fasten it to a wooden board with strips of sticky tape

Making work easy

Choosing the right work surface

Have you decided where you will do your painting?

If you have your own room, you already have your artist's studio.

The table or desk on which you do your homework is fine for watercolour painting. Just cover it with paper to avoid getting it dirty.

You can also place the pad of paper on a wooden board. Hold one end of the board on your knees and prop the other end against the edge of the table while you paint.

These are the materials a watercolour painter needs: a watercolour paintbox, a pad of paper, brushes and water containers; also, a roll of paper towels for squeezing out the brush and a sponge for absorbing water or paint.

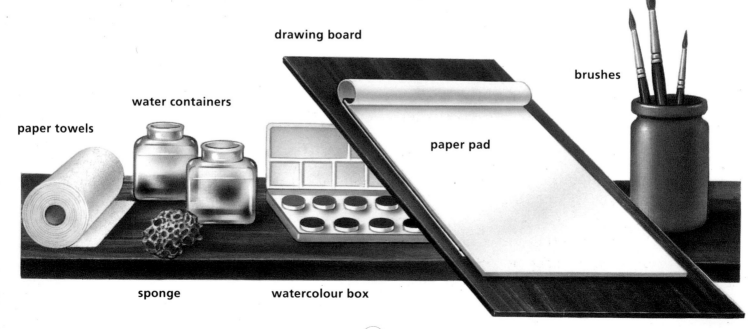

drawing board

brushes

water containers

paper towels

paper pad

sponge

watercolour box

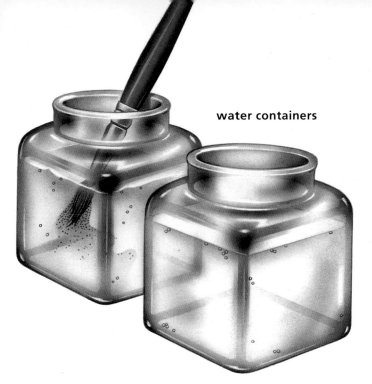

water containers

Other tools & materials

Other materials

You need very few other materials - just paper towels, for example kitchen towels, and a sponge.

paper towel

sponge

Water containers

In watercolour painting, the water used to dilute the colours is as important as the colours and brushes.

You will need two glass jars with wide necks. Fill both with tap water.

Keep one jar for rinsing and cleaning the brush every time you use a different colour. Use the other jar to wet the clean brush before picking up a new colour.

Paper towels are useful for squeezing out your brushes as well as drying them after you have washed them. Use the sponge to absorb excess paint.

Painting skills

Before starting to paint...

You've collected your equipment and you're ready to start painting. Before beginning to paint, try a few skills on a piece of test paper.

Choose a colour and dilute it with water. Notice how the colour intensity varies depending on how much water you use.

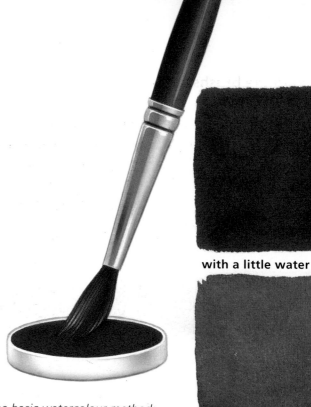

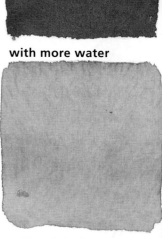

with a little water

with more water

with a lot of water

The basic watercolour method: wet the brush and rub the colour. Depending on the amount of water used you will get lighter or darker tones. For instance, if you pick up a colour with an almost dry brush, you will have a dark tone; if you use a little more water, the colour will be lighter; and if you use a great deal of water, you will have a pale colour.

Making the brushstrokes

You need to be able to handle the brush well before starting to paint. Practise your brushwork over and over again on a piece of test paper before beginning.

Pick up the colour with the brush, squeeze out the brush on a paper towel, then place the tip of the brush on the paper. Press the brush until the tip bends a little and paint a horizontal strip. Try to develop a firm, bold brushstroke, which should be a continuous one. Don't worry if you find this difficult to start with. Continue practising again and again.

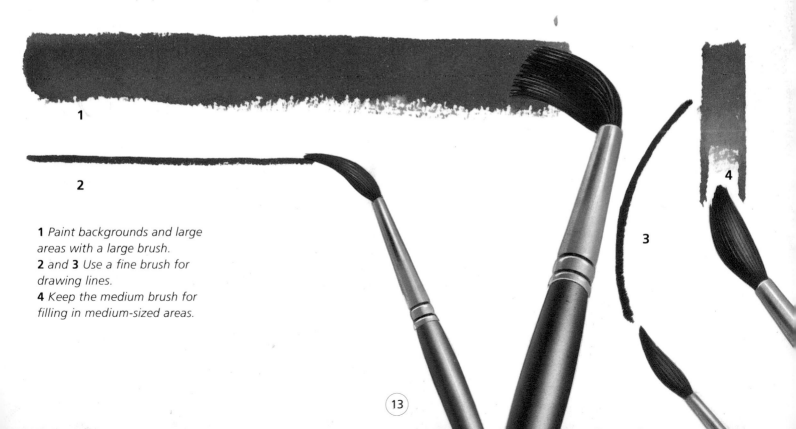

1

2

4

3

1 *Paint backgrounds and large areas with a large brush.*
2 and **3** *Use a fine brush for drawing lines.*
4 *Keep the medium brush for filling in medium-sized areas.*

Painting skills

Painting an even background

Painting an even background in watercolour - that is, in a colour that looks the same all over - is not difficult, but it needs practice.

Wet the brush and pick up a little blue colour from the cake. Paint a horizontal strip, pressing the brush against the paper to make a wide strip. If your board slopes at an angle, the colour will run down to the lower edge of the strip. Paint another strip below the first one, and continue painting strips until you reach the edge of the paper.

When you reach the lower edge, you will have too much paint. Wash the brush with water, dry it with a paper towel, and apply the tip of the brush to the paint that has accumulated on the lower edge. The brush will act like a sponge and soak it up. And you will have an even background!

paint a horizontal strip

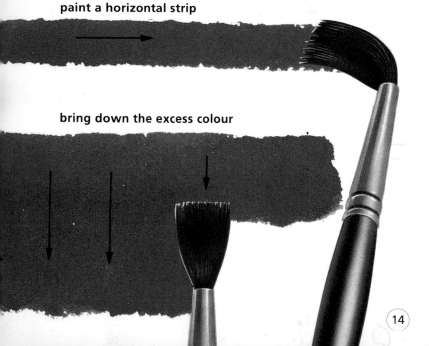

bring down the excess colour

soak up the excess colour at the bottom

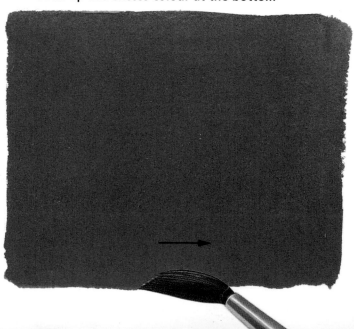

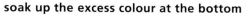

Learning to gradate colour is very useful for shading. Try this method on a piece of test paper.

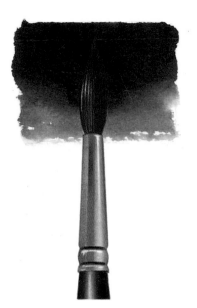

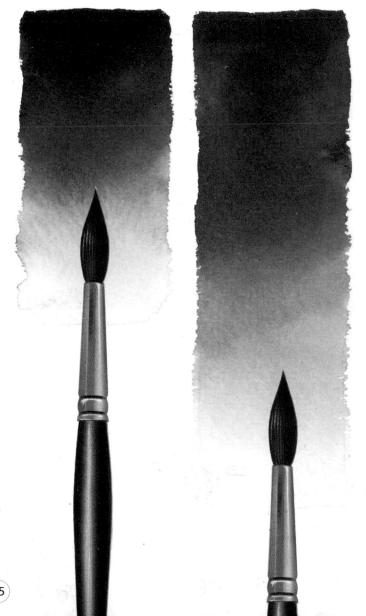

Painting a gradation

First pick up a little colour with a brush that is slightly wet and paint a strip. Clean the brush in water and wet the paper below the strip. While the strip is still moist you can spread the colour with brushstrokes down into the wet area. When the colour has been used up, stop. Clean the brush, dry it with a paper towel and put it in the middle of the gradation.

Pick up any water that has collected and continue to spread the colour while retouching the area you have already painted.

15

Painting skills

Building up layers of colour

In watercolour painting you must first paint the light colours and then the dark ones.

This allows you to build up darker colours by means of extra layers of colours.

A very diluted colour will give you a very clear tone. If you wait until it dries and apply a new layer, you will create a darker tone.

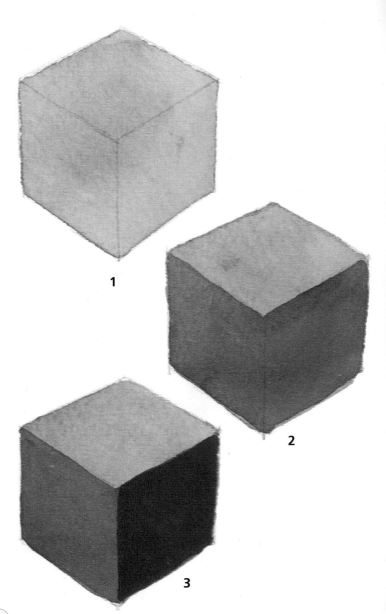

Painting this cube will show you how you can create darker tones by painting one layer of colour on top of another. **1** *First paint all sides of the cube with the same value of a colour.* **2** *Wait until it dries and apply another layer on the darker areas.* **3** *When they are dry, apply a new layer on the darkest face.*

Reserving whites

Reserving whites means leaving white or light areas unpainted.

This means that before beginning to paint, you need to do a drawing to show where the white areas will be (or to reserve them).

Changing colours

In the previous pages you have used one colour; but watercolour painting usually involves many colours.

Does this mean that you should use a different brush for each colour? Not at all. You just need two or three brushes that you must clean after applying one colour and before picking up a new one. Otherwise, the brush will make the new colour dirty.

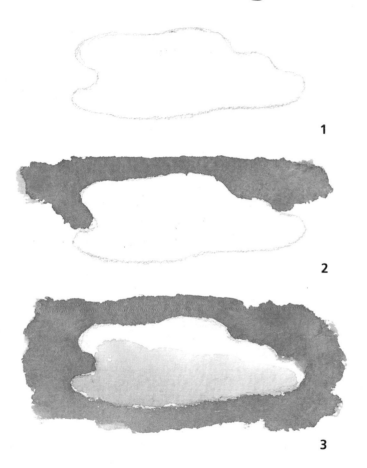

1

2

3

*When you paint a watercolour with white or light areas you need to show where they will be. In the following example, paint the sky, reserving white areas for the clouds. **1** Draw the clouds and **2** paint the sky outside the pencil lines. **3** Then, if you like, you can shade in the clouds.*

Painting skills

Discovering primary colours

Among the colours in your paintbox are the three *primary colours*–blue, red and yellow.

If you mix each of the three primary colours with another you create three new colours: purple, green and orange which are called *secondary colours*.

The colour wheel

If you continue to mix colours you can create a colour wheel of 12 colours. This wheel helps to explain the relationship of the most important colours.

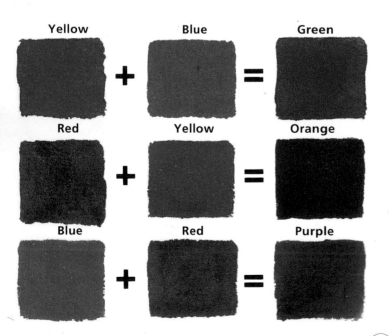

Yellow	Blue	Green
+	=	

Red	Yellow	Orange
+	=	

Blue	Red	Purple
+	=	

Here you can see that mixing the three primary colours creates three secondary colours. These in turn, mixed with the primaries, give you six tertiary colours.

Colours which are opposite each other on the colour wheel are called the *complementary colours*. With complementary colours the most intense contrasts can be achieved.

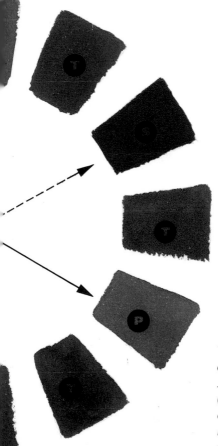

The colour wheel is made up of 12 colours: 3 primary (P), 3 secondary (S), and 6 tertiary (T). The arrows link complementary colours - that is, those colours that produce the most contrast.

Colour and value

You see the colour of objects as lighter or darker depending on the effect of light and shadow.

Value is the degree of lightness or darkness of colour depending on the lighting or shading of an object or a part of an object.

In the sphere below you can see different values of blue, ranging from the palest blue, almost white in the lightest area, to the darkest blue in the shadows.

different values of a colour

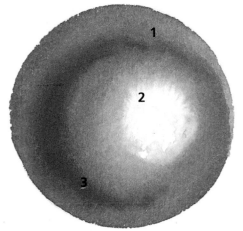

1 medium value
2 light value
3 dark value

First projects

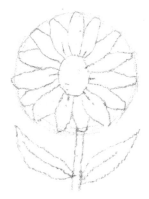

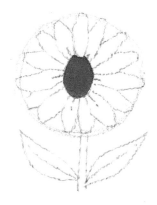

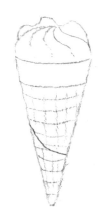

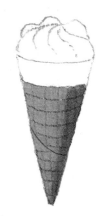

Draw a circle around the outside of the petals, two lines for the stem and two for the leaves.

With a fine brush, paint the centre of the daisy dark yellow without going outside the pencil lines.

Draw a cone in as much detail as possible. Don't press the pencil too hard on the paper.

Paint the cone orange with a very wet brush. Before the watercolour dries, paint the darker gradation with a drier brush.

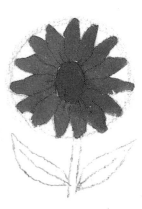

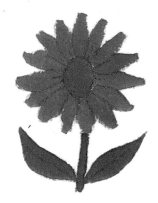

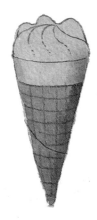

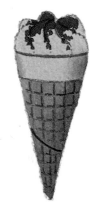

Clean the brush and paint the petals light yellow; follow the pencil line and then fill in with colour.

With a clean brush, outline the stem and the leaves with light green and then fill in with colour.

Blend blue and red and paint the ice cream. When it dries do a little gradating with the brush loaded with more colour.

Paint the ice cream light yellow and the cone lines brown.

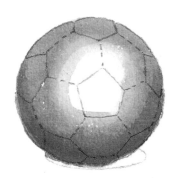

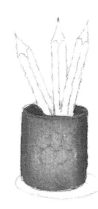

Draw a circle to enclose the ball shape. Then draw the design of the stitching.

Paint the ball dark yellow. Wait until it dries a little and then gradate the colour using a wet brush.

Carefully draw the upper area and the base of the jar. Draw the base as an oval. Rub out the curve of the back of the jar later.

Paint the jar light yellow. When it has begun to dry, add a bit of orange and gradate.

Blend blue and a bit of red and paint the shadow. As before, wet the brush and gradate the shadow

With a damp brush, use brown for the middle and upper design shapes. Use a drier brush for designs below.

Paint each pencil with a very wet brush. Then, blend blue with a bit of red and paint the shadow cast by the jar.

Add a new layer of the first colours on the dark areas of the pencils but use more colour with a drier brush.

First projects

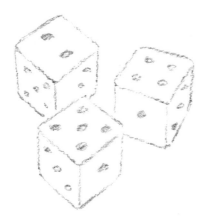

Now you can practise painting different values of the same colour. You need to decide whether you should use a lot or a little water to create a lighter or a darker tone. Begin by drawing the dice.

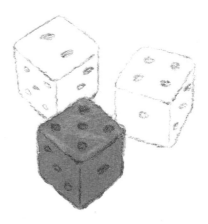

Pick up some light yellow with a lot of water and paint a die evenly. It doesn't matter if you paint on the pencil lines, but try not to go outside them.

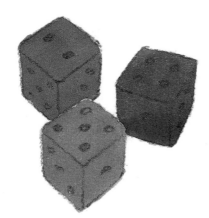

Wait until the colour is dry before painting the other dice. Wet the brush, moisten the cake of light green, and paint the second die evenly. Do the same for the third die in light red.

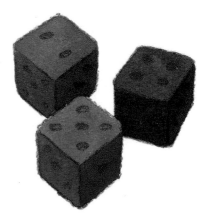

When the colours are dry you can begin painting the sides of the cubes. Wet the colour to paint lighter areas and use an almost dry brush to paint the darker areas.

To paint this top you will need to paint several stripes in different colours. In watercolour it is important to learn how to paint two or more colours next to each other without dirtying them.

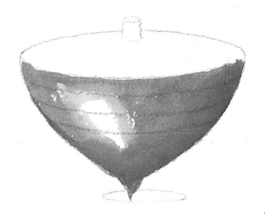

Paint an even background in light yellow, reserving the highlights. Before the colour dries completely, blend yellow and a bit of orange and gradate the colour on the right side of the top.

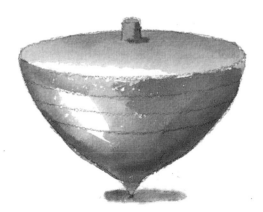

Continue gradating with yellow and orange to emphasize the form of the top. Blend blue and a bit of red on the lid of the paintbox. Paint the shadow of the top and gradate the colour with a dry brush.

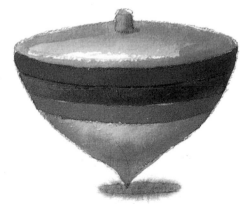

Paint the stripes orange, blue and yellow. Let each stripe dry before painting the next one. Paint the shadows on the right with drier orange and blue and add a bit of yellow ochre to the yellow.

First projects

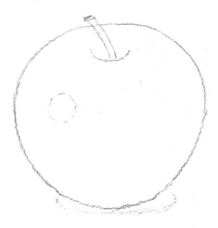

Painting this apple will help you learn how to gradate a colour to paint shadows. First draw the subject carefully, marking the highlights.

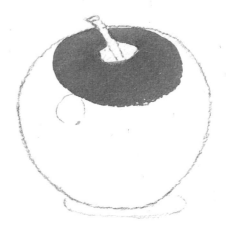

Wet the brush and put light yellow on the lid of the paintbox. Add more water if necessary to achieve a lighter tone. Pick up the colour and paint the upper part of the apple.

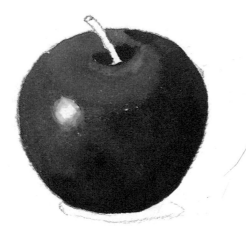

Clean the brush and pick up a little red. Paint from below and spread the colour until it reaches the still wet yellow colour. Then, paint a red stripe on the right side.

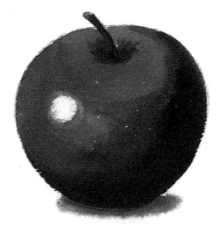

Wet a fine brush and pick up light green to paint the apple stem. When it is dry, paint the shadow dark green. Clean the brush and paint the shadow of the apple blue with a bit of red.

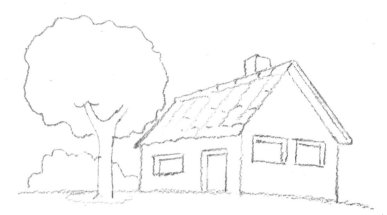

Draw the house, making all the vertical lines - walls, door, windows - parallel. The horizontal lines rise as they approach the front of the picture (foreground) and fall as they move back (background). Only the horizon is drawn as a horizontal.

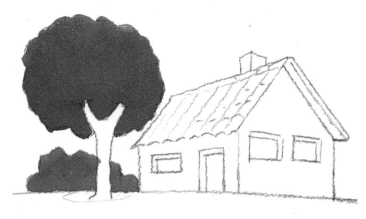

Wet the brush and paint the treetop light green, outlining the upper part and spreading the colour down. Outline the lower part and fill in the rest with colour. Wet the brush and paint the bush.

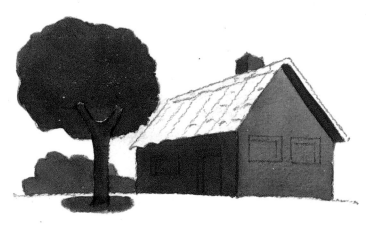

Paint the house with very wet yellow ochre. When the colour is dry, blend yellow ochre with a bit of brown and paint the front of the house darker. Do the same with the chimney. Then paint the tree trunk.

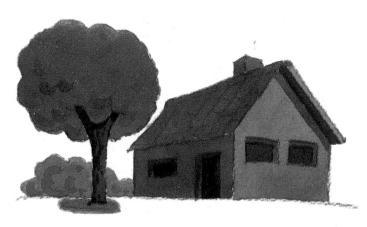

Paint the roof; use more water with the red to paint the lighter areas. Use dry yellow ochre on the roof shadows and on the windows. Using very little water, paint the tree and bush shadows dark green.

Advanced projects

The four pictures that follow will help you practise everything you've learned about watercolour.

Read the text and look at the illustrations before starting to paint. Follow the steps in the order suggested.

As well as the illustrations showing you every step, you will find some illustrations that explain how to paint certain details.

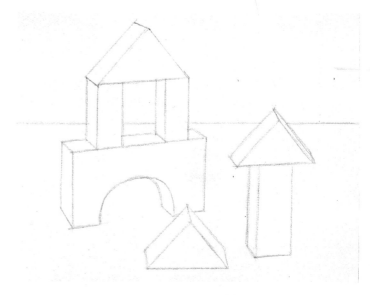

Start by painting these building blocks to practise painting different values.

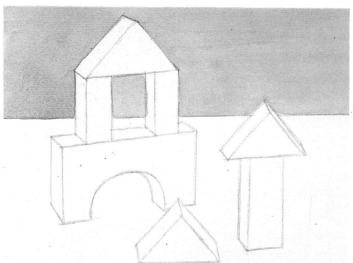

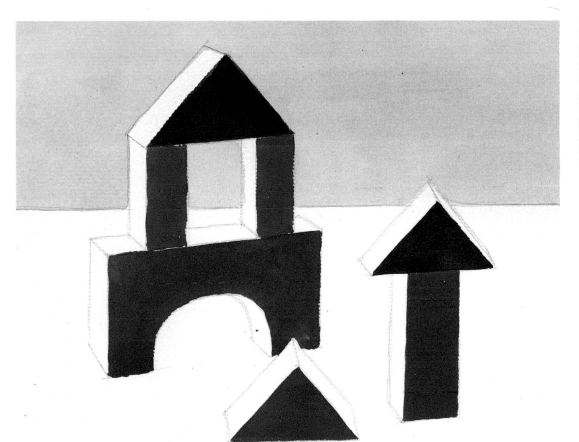

When applying paint, follow the lines of the drawing first, then spread the colour.

Draw the subject without pressing the pencil too hard on the paper.

Paint the background with light blue and a small amount of yellow ochre. Begin on the horizontal line and spread the colour upwards.

Wait until the background is dry before painting the building blocks. Paint the different blocks red, light yellow, orange, light green and light blue.

Advanced projects

Paint the sides with a fine brush, adding a lot of water to the cake of colour.

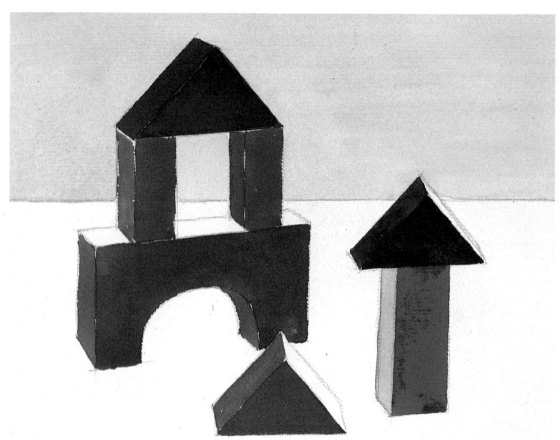

The next step is to paint the sides of the objects in lighter values of the previous colours.

Use a fine brush and quite a lot of water.

Before painting, test the colours on the lid of the paintbox to check that the tone is light enough.

If you feel it is too dark, add some water.

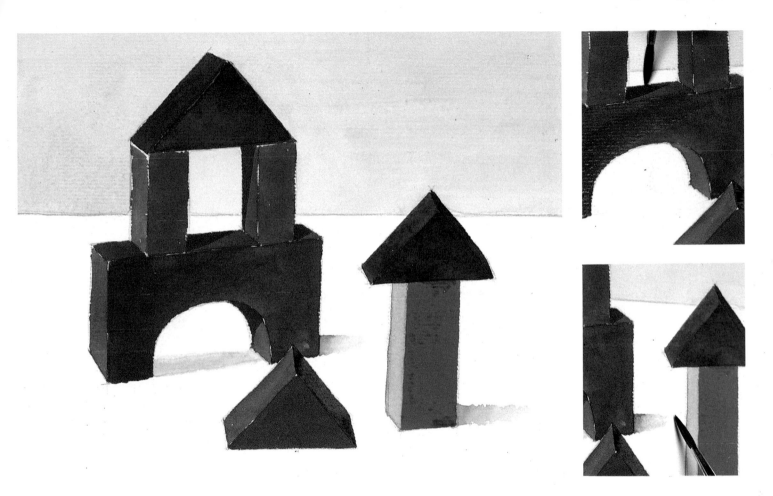

Now paint the upper part of the arch-shaped piece with yellow and a small amount of red.

Paint the red triangles with red and a little bit of blue, and the green triangle with dark green.

The dark tone can be created by using a fairly dry brush. Finally, use an almost dry brush and paint the inner shadows of the arch in brown. Use blue and a lot of yellow ochre for the other shadows.

Advanced projects

Painting this picture will help you to practise a very important skill painting even backgrounds and gradated backgrounds. Draw everything that you see on this page in as much detail as possible.

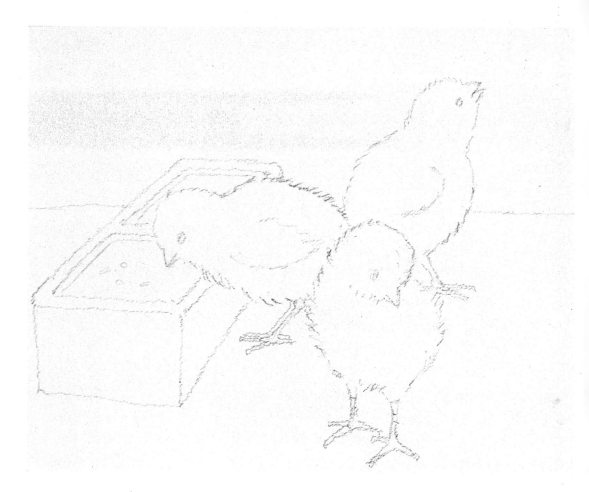

This painting continues work on backgrounds. It will also help you practise drawing outlines and filling them in with colour.

Draw the shape of the chicks and the feeder.

Then draw all the lines necessary to separate each object in the picture.

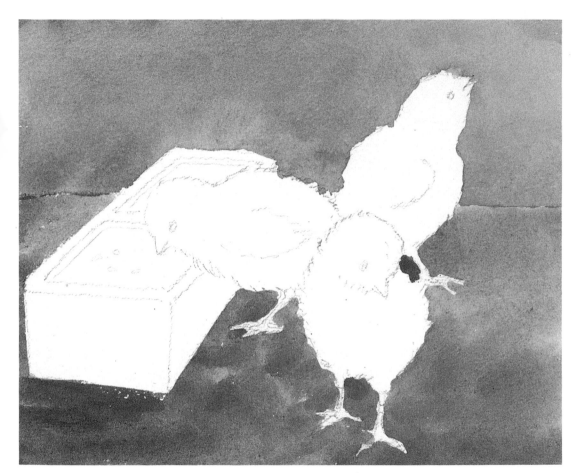

Paint the upper background first. Pick up light green with a thick, wet brush.

Paint horizontal brushstrokes from left to right and flow the paint down, taking the wet colour up to the pencil line.

When the colour is dry, clean the brush and paint the lower background in yellow ochre with a lot of water.

Advanced projects

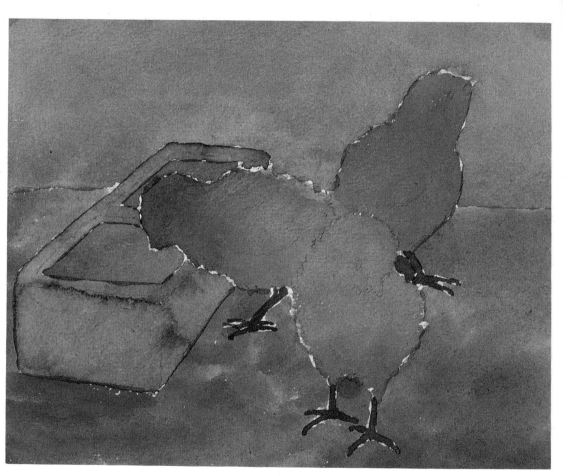

When the backgrounds are dry, wet a medium-sized brush and paint the three chicks light yellow with a lot of water. Paint along the pencil lines without going outside the chicks' outlines.

Clean the brush and paint the corn orange and the feeder brown. Using a fine brush, paint the chicks' legs orange and then outline the feeder in dark brown.

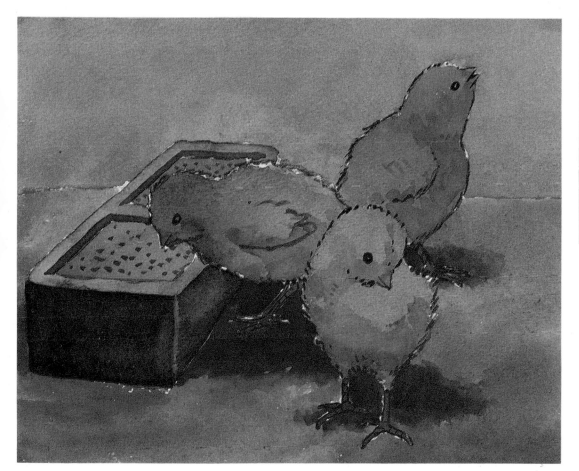

Paint the chicks' shapes with a fine brush; use short brushstrokes for the feathers.

Use a fine brush and paint the dark side of the feeder brown. Add some water to paint the light side. Blend light yellow with some orange and paint the chicks' wings.

Still using the fine brush, paint the last details. Use brown for the eyes and red mixed with brown for the chicks' shapes and the shadows of the wings.

Advanced projects

*This yacht will help you
practise background painting
– sky and sea – and painting
without dirtying the colours.*

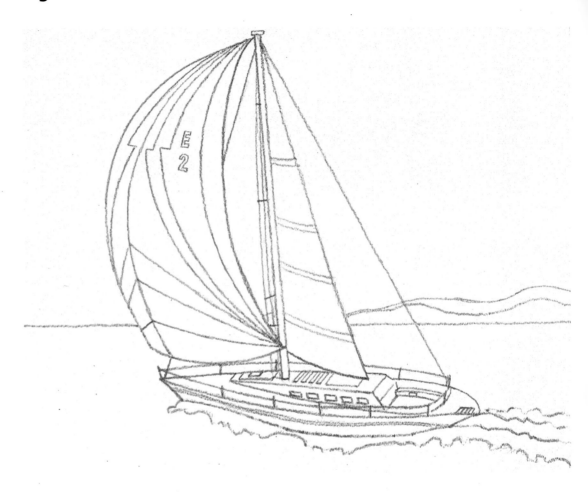

Draw the mainsail and the hull of the yacht, following the drawing on this page. Use a ruler for the jib and the mast.

Don't press the pencil too hard on the paper. Then draw the line of the horizon and the shape of the mountain. Draw the waves around the yacht, so you can reserve them later when you begin painting.

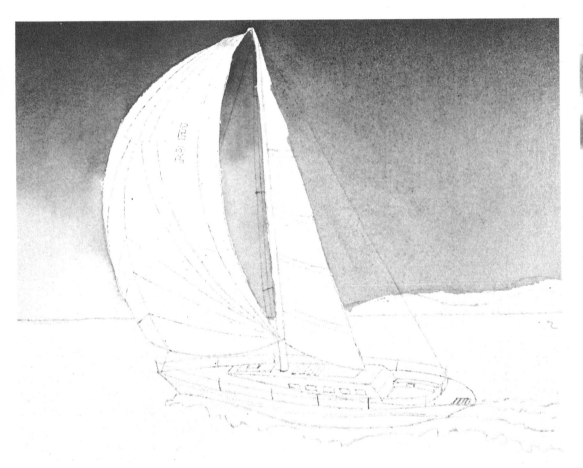

Try to paint an even background without streaks of colour. Also, avoid going inside the area of the sails.

Begin painting the sky light blue with a thick wet brush. Use horizontal brushstrokes and take care to leave the sails white.

Paint in long, continuous brushstrokes to avoid streaking caused by drying paint.

Dry the brush and quickly gradate and blend colour in the area you've just worked on.

Advanced projects

Below the yacht, take the colour upto the pencil lines to define the waves.

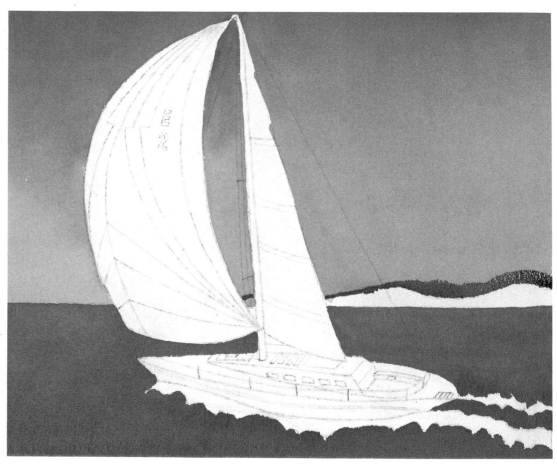

Clean the thick brush and begin painting the sea dark blue. Take the colour from the horizon line downwards. Before it dries, apply paint with less water to the bottom foreground, to darken it.

Be careful not to go past the pencil line when you're painting the lower part of the hull. Use a medium brush to paint the mountain light green. Use less water to paint the shadows.

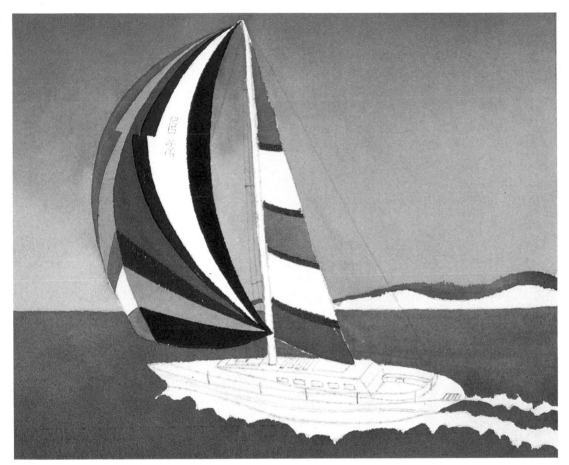

Paint the stripes of the sails: first make pencil lines, then fill in the colour of the stripes.

Use red, blue, and light green for the mainsail and light yellow for the jib.

When the colours are dry, paint the dark tones in the same colours but with a drier brush.

Advanced projects

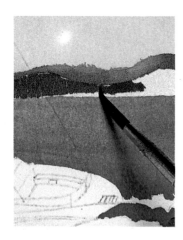

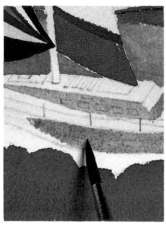

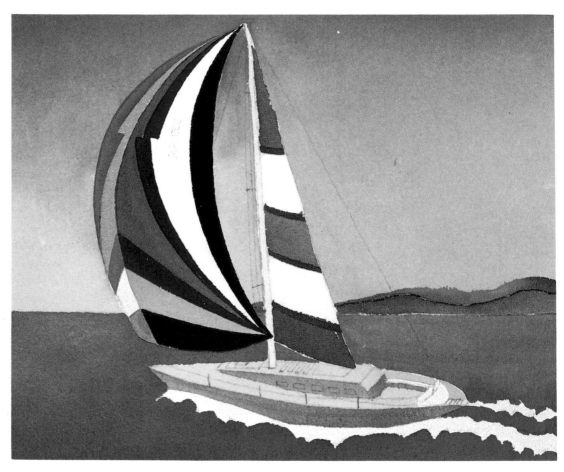

Pick up light blue with a fine brush and, with even brushstrokes, paint the hull and deck.

When the colour is dry, paint the stripe on the hull and the windows light blue with a drier brush.

Then paint the hull dark blue, first outlining the shape.

Finally, with a drier brush, gradate the right side of the hull.

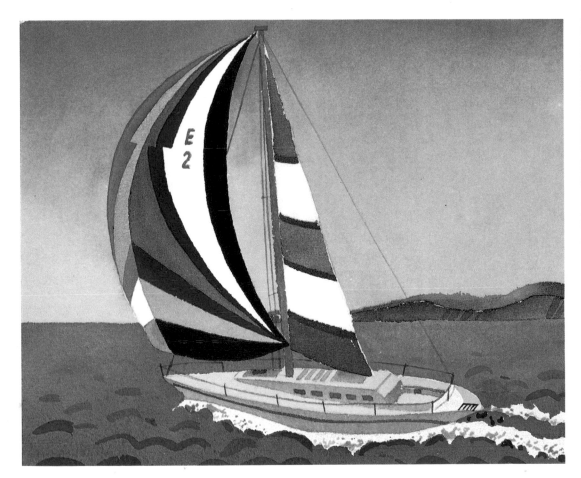

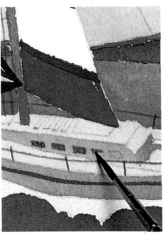

Use a fine brush with very little water to paint the windows dark blue over the light blue background you've already painted, which should be dry.

Now paint the last details.

Blend dark blue and a little red and add water until you obtain the violet colour of the railing and other details on the deck.

Paint the foam of the waves light blue, making slight splashes with the same brush.

Finally, paint the waves, making them darker in the foreground and lighter in the background.

Advanced projects

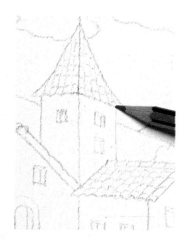

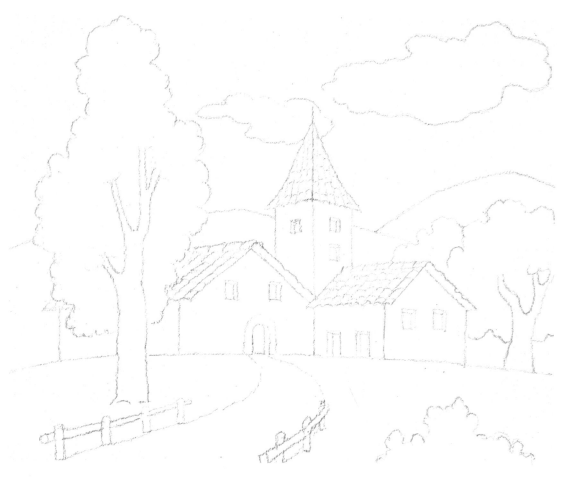

This landscape will help you to practise all the skills you've learned. First, draw all the details, paying special attention to the houses and the tower.

Painting this landscape will enable you to practise backgrounds and gradations, outlining shapes and filling them in with colour, and, above all, gradating colours to paint shadows.

First, complete the sketch. Just outline the houses and landscape - without any shading.

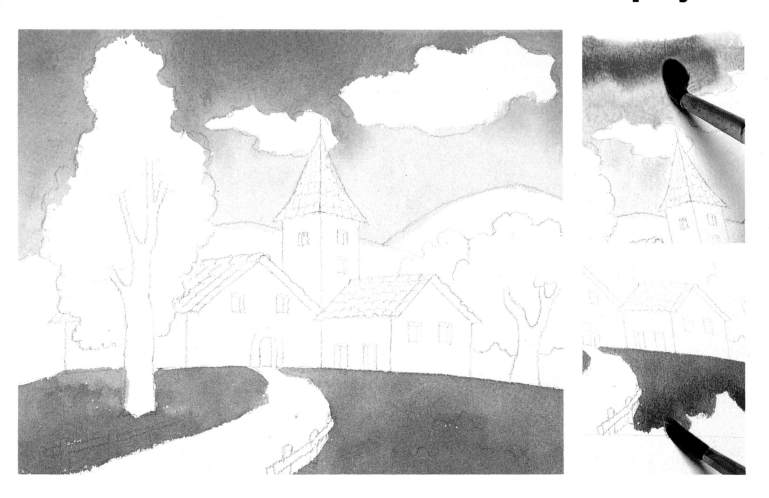

Begin painting the sky light blue. Wet the brush and flow on the colour. Then pick up some more colour with a drier brush and apply brushstrokes to the upper part.

Paint the meadows. Blend green with some yellow and flow the colour downwards.

With a drier brush, paint the foreground and gradate upwards for a lighter green.

Advanced projects

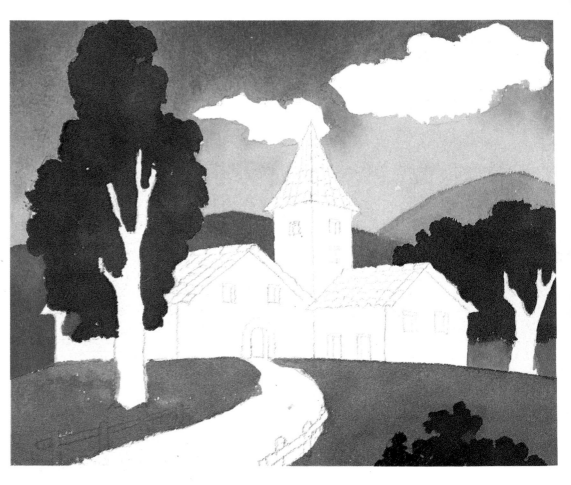

Paint the trees, spreading the colour with enough water. Paint the outline of the branches when you paint the lower parts of the treetops.

Now, paint the mountains. Use green with some blue to paint the mountain on the right. Add a bit of green for the mountain on the left.

Pick up some more green with a wet brush and paint

the trees. First, paint the shape of the treetops and then fill in with colour.

Before it dries, work in the colour with a fine, dry brush to create shades.

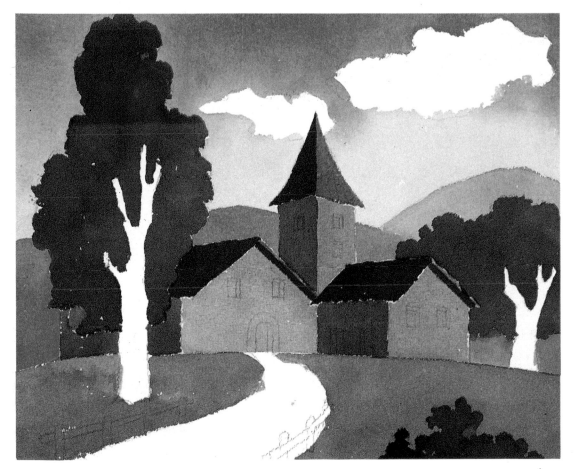

Paint the roofs red with an almost dry brush, beginning as always with the pencil line. Use a wet brush to paint the highlighted area on the roof of the tower.

Use red with a wet brush for the roofs. Use a drier brush for the darker areas.

Clean the brush and paint the front of the houses and the tower. Use a wet brush with yellow ochre for the light tones and brown with green for the dark ones.

Use brown with a little green under the eaves.

Advanced projects

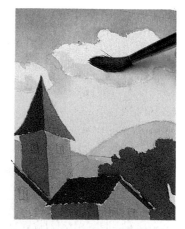

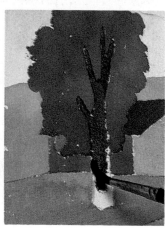

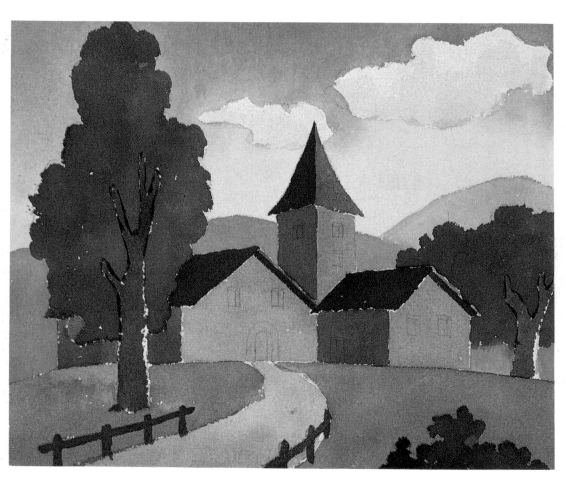

Next paint the path dark yellow and red. Use a lot of water to spread the colour. Paint the foreground of the path with less water than the background and then link both tones. Paint the shadows of the clouds, gradating light blue and dark blue. Blend brown and green to paint the branches and trunks of the trees. Clean the brush and paint the fences brown with some yellow ochre.

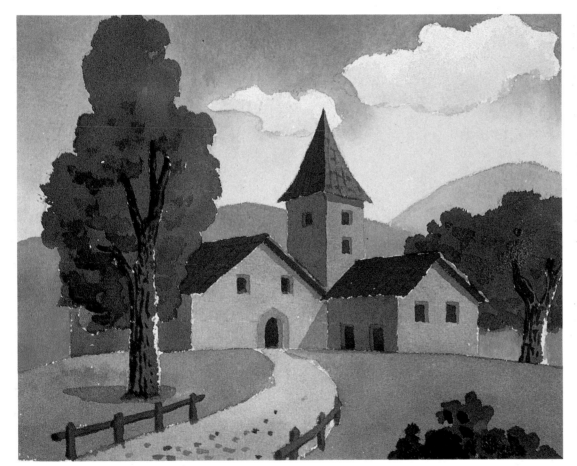

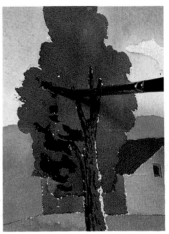

Blend dark green and a little brown. Then, paint the tree shadows with a fairly dry brush.

Use a fine brush to paint the final details. With very little water, use yellow ochre and some green for the shadows cast by the buildings. Paint the doors and windows with yellow ochre and brown, using a lot of water. The shadows formed by the treetops and trunks are brown with some dark green. Paint the stones on the path orange with quite a lot of water.

45

Glossary

background. The most distant level of depth or distance in the scene.

colour wheel. A circle made up of twelve colours: three primary colours, three secondary colours and six tertiary colours. Another name for the colour wheel is chromatic wheel.

complementary colours. The secondary colour created by mixing two primary colours, which is said to be complementary to the third primary colour (for example, green, created by mixing blue and yellow, is complementary to red).

composition. The arrangement of all elements of a subject in a pleasing way.

cool colours. The colours in the colour wheel between green and violet, with both these colours included.

foreground. The nearest level of depth or distance in a scene.

form sketch. First lines in a drawing that set down the basic forms of a subject using simple geometric shapes (squares, rectangles, circles, etc).

gradation. The gradual shift from a darker tone to a lighter one or vice versa.

middle ground. The level of depth or distance in between the foreground and the background in a scene.

outline. A quick sketch that with a few lines roughly sets down the basic elements of a subject.

palette. A thin board on which a painter mixes colours; also, the complete range of colours used by a particular artist.

perspective. Drawing rules for creating on paper, which has only two dimensions (length and width), the impression of the third dimension (that is, depth).

plane (or ground). Different levels of depth or distance in a scene. In a landscape, for example, there may be: a foreground - the nearest; a middle ground - the level in between; and a background - more distant.

primary colours. Red, blue and yellow; the colours that are blended to produce other colours, but that cannot themselves be created by mixing.

scale. A group of all the tone variations in a colour.

secondary colours. Orange, purple and green; the colours created by blending pairs of primary colours.

shading. Capturing light and shadows through gradation of different tones

sketch. A rough drawing or painting in which the shape, composition and tonal values of light and shadows are shown.

still life. A drawing or painting based on a collection of objects arranged in a particular way by the artist.

tertiary colours. The colours created by blending a primary and secondary colour (for example, blue-green or red-orange.)

tone. Intensities of a colour, from the lightest to the darkest.

transparent colour. A layer of colour through which the colour underneath can be seen.

value. The degree of lightness or darkness of a colour. A weak value is very light (or pale); a strong value is dark and intense.

warm colours. The colours in the colour wheel between crimson and light yellow, with both these colours included.